Presented To:

Jasmine

From:

Unita

Romans 12:2

Date:

September 28, 2019

TRACEY SMITH

HEAVEN'S
PLAYGROUND

4

TRACEY SMITH

HEAVEN'S PLAYGROUND

NEW BEGINNINGS CAN SOMETIMES BE DISGUISED AS PAINFUL ENDINGS

Advanced Global Publishing

P.O. Box 310, Shippensburg, PA 17257-0310

Cover design by: Emanuel Brown

ISBN 13 TP: 978-0-7684-1056-3

ISBN 10: 0-7684-1056-8

For Worldwide Distribution, Printed in the U.S.A.

2 3 4 5 6 7 8 / 21 20 19 18 17

DEDICATION

I dedicate *Heaven's Playground* to my daughter, Trezoree Isis House. Thank you for inspiring me to do more and to be a better me. Your strength and courage in the face of adversity was undeniable. As I watched you take your chemotherapy treatments, blood transfusions, platelet transfusions, and spinal taps with such bravery, you showed me how to never give up in the midst of setbacks. Watching and helping you battle the cancerous disease, leukemia, has brought me closer to God. Although I wanted you to stay here with me on earth, God made a promise to me that I would see you again in Heaven. Thank you for giving me four wonderful years of your life and happiness. And

thank you for gently escorting me to my day of new beginnings.

To my beautiful sons, Rodney and Gabriel, thank you for your love and support. After losing Trezoree, you gave me another reason to live and enjoy my life again. I must say the two of you kept me thoroughly busy and my mind moving in the right direction. Thank you for being two awesome kids. I'm so proud of you and love you both unconditionally.

To my beloved aunt, Doris Mack, thank you for consistently checking on me and the progress of my book. Thank you, Auntie, for pushing me and having faith in me and my story of how God brought me love and hope during a very sad time. I'm looking forward to seeing you again in Heaven.

ACKNOWLEDGMENTS

To my loving husband, Raymond, thank you for picking up the pieces in our lives and carefully putting everything back together again and in the rightful place. Thank you for showing us leadership and providing us with direction. Without you, our day of new beginnings would not be complete. Growing with you and loving you has been an awesome blessing from God. I would be remiss if I did not take the time to thank you for your continuous love and support throughout this project. Thank you for being the creative force behind the scenes.

Throughout this writing project I asked myself questions including: *Did I have a logical flow of thought? Does my story move along at*

a consistent pace? Do I elaborate enough on my experiences and have good Scripture support? It was during this time when I reached out to my cousin, Attorney at Law Ronald E. Richardson for guidance and support. Ron generously volunteered to assist me with editing my story. The edits and feedback that I received from Ron helped me move forward and work toward completing this book. I am eternally grateful, Ron, for your help and willingness to be a blessing.

I would be nothing without a strong faith foundation and consistently being taught the Word of God. I would especially like to thank my pastors, Drs. Mike and Dee Dee Freeman, for teaching me how to *live by faith* and walk boldly in God's commandments. I can't thank them enough for their love and support throughout the years. They taught me that all things are possible if only I would believe. It's been a complete honor and privilege to sit up under their teachings and grow while seeing the blessings of God expeditiously come to pass in my life.

Contents

12

INTRODUCTION

As we journey through life we expect certain things to happen. Becoming successful, getting married, buying a home and having a family. All these things are what most people expect to achieve throughout their lives.

What life doesn't prepare us for are the unexpected events—such as losing a child.

All people have lost family members or close friends during our time here on earth, but losing a child, a precious baby, is one loss we are never ready for. This was truly my most painful unexpected tragedy in life.

How would I survive after losing my baby girl to a tragic disease?

The birth of a child is so exciting, especially when the child is your firstborn. Even in the midst of a marriage that's not going well, the anticipation of having a child brings excitement and joy to you and everyone around you. On April 16, 1992, my daughter Trezoree Isis House was born and a newfound love permeated my home.

Trezoree gave me happiness and direction. I could never imagine my life without her. But in just a few years, the one person who brought me the most joy and happiness I had ever known was facing a life-threatening disease.

At this time in my life, I was not acknowledging God or being led by His voice. Other issues clouded my mind. Eventually, though, during my daughter's struggle to live and my struggle to cope with the fear of losing her, I was able to hear the voice of God and acknowledge His presence. This newfound relationship with God equipped me to get to the other side of the tragedy—which was my *new beginning.*

The love between a parent and child is like none other; the love is immeasureable, unbreakable, and brimming with endless hopes and dreams for the future. I truly know that mothers love all of their children, but I must say I really believe there's something very special about a mother and daughter's love.

CHAPTER 1

Mother's Love

The love between a parent and child is like none other; the love is immeasurable, unbreakable, and brimming with endless hopes and dreams for the future. I truly know that mothers love all of their children, but I must say I really believe there's something very special about a mother and daughter's love.

As a young girl and also as a young woman growing up in a house with two sisters, we didn't have many "things," but love was always present. The relationship with my

mother was very important to me because no father was present in our home. Not understanding why there was no father in my life was very confusing throughout most of my childhood life. I often had dreams of having both a mother and a father raising me and giving me all the love I could ever want. Although that never happened, my mom provided my sisters and I with endless love.

Being a single parent, my mom did everything in her power to take care of me and my two sisters. She didn't have much to offer us financially; however, she was able to provide us with most of what we needed. I now realize that she was doing the very best she could do to support us with what she had. Every birthday, along with every holiday, my mom showered us with love and many special gifts.

My mother, along with my grandmother, raised and provided for me and my two sisters. Although they gave us what we needed, it was really exciting to have our wants granted on special occasions. Having extended family gave my sisters and me opportunities to travel, visit amusement parks, and attend different events throughout the Baltimore, Maryland, area. I always

felt my mom was very thankful that her family chipped in and helped her girls. Extended family members played a major role in shaping my life.

I was raised in West Baltimore where my mom, my two sisters, and I lived with my grandmother in a neighborhood of closely connected row houses. The row houses were very shabby and small and most of the families that lived in my neighborhood were probably on welfare, some had drug problems, and drug distribution was evident throughout the entire block. As a child growing up in this type of environment, I didn't understand or realize the type of setting I was being raised in. Things at the time seemed normal to me.

During summertime, there were so many kids on our block. I made many friends and we all played together. I remember riding my bike with the children in the neighborhood, and in some of the backyards there were clubhouses where the kids played fun games.

But there were also many troublesome things happening within my neighborhood. The crime rate in the general area where I lived was extremely high. I never felt like

I was in any danger, but looking back and reflecting on my mom's demeanor and nurturing methods, I now understand why she guarded over us so carefully.

My mom and grandmother were very protective of me and my sisters' daily activities. Mom walked us to school each and every morning and kept a very close eye on our whereabouts in the neighborhood. We had to get permission before leaving our front steps, walking to the candy store, or playing any types of games that took place in the neighborhood street.

My mom never owned a car and we would often wait for a relative to come by and take us places outside our neighborhood. These were very exciting times for my sisters and me because we enjoyed being with other family members; most of the time it was either my mom's sister or her brother who would take us to the park or the malls or to parades. These were highpoints for me and my sisters that we would talk about for days and weeks afterward.

As a youth, I often dreamt of becoming a famous actress or fashion model. Whatever I saw on television or heard on the radio, I found myself daydreaming that one day that

would be me. I had many dreams that one day I would be famous.

As a young girl, my mom saw how acting and modeling was so important to me. With a little persuasion I convinced her to take me to casting calls and modeling auditions. I was really nervous attending the auditions; however, I was very excited that my mom agreed to take me and allowed me to be part of it. Even though I auditioned, I felt there were so many more opportunities that my sisters and I missed out on. I remember feeling like there was so much in life I wanted to achieve and accomplish.

PICTURE PRAYING

Living with my grandmother provided a sense of stability in my mom and within our lives. I remember being in my grandmother's room and sharing many precious moments. My grandmother was sweet-spirited with a quiet demeanor. I spent many nights lying across her bed watching television with her, and whenever I was sick she was always there to comfort me. In my grandmother's room she had a wooden Bible case with a photo of Jesus painted on the inside. This picture

really intrigued me. It seemed that Jesus was looking at me every time I entered her room.

During this time, I started attending church with my next door neighbors every Sunday. After church I often found myself heading back to my grandmother's room and praying to the picture of Jesus inside the wooden Bible case. This was the beginning of me establishing a prayer life at a very young age. It made me feel that God was present in my life. Whenever I felt I needed something or my family needed something, I would return to the picture of Jesus and begin to pray. Looking back now, I realize this was the beginning of me creating a relationship with God.

I had many dreams of being an inspirational mother to a teenage daughter. I pictured us going places, getting pampered together; and enjoying days as mother and daughter. I even pictured her attending college, getting a degree, and achieving all of her career goals. I thought one day I would see my daughter walk down the aisle, get married, and have children.

CHAPTER 2

Unfulfilled Dreams

Becoming a young woman, my main priority was to establish a stronger and more stable life, contrary in many ways to how I was raised. I truly wanted to be married to a loving, caring, and providing husband. This was something that was not evident in my home. I wanted children and a stable family foundation that would create a better environment for them than the one I had. I always pictured myself with a little girl who had a beautiful, smart, and great personality. There were times I dreamed of molding

her, shaping her, and developing her into a better me.

I wanted to make a better me.

I imagined myself raising a little girl who would not have to endure many of the hardships that I encountered growing up. I felt I could give this little girl a great life, encourage her to be the very best, and assist her in making decisions that positioned her to achieve all of her dreams. I envisioned her having certain specifics, some perhaps the same as my characteristics: cute, a beautiful smile, adorable eyes, and long black curly hair. I pictured her being very intelligent as well as incredibly outgoing.

I had many dreams of being an inspirational mother to a teenage daughter. I pictured us going places, getting pampered together, and enjoying days as mother and daughter. I even pictured her attending college, getting a degree, and achieving all of her career goals. I thought one day I would see my daughter walk down the aisle, get married, and have children.

As I got older, during all of these daydreaming moments, I never included or

consulted with God about His direction for my path. Unknowingly, I planned to do all of these things on my own, without God. At this time there was a sense of emptiness in my soul and a real feeling of wanting love. All along I had no idea how these dreams would take place and how important it was to have God at the center of my life.

MARRIAGE WITHOUT PURPOSE

I thought if I found the right person, I would eventually get married and create a new life for myself and a future family. I was married at the age of 23—for all the wrong reasons. I married to escape an underprivileged life; a life surrounded by poverty and lack. Circumstances did not present an ideal situation for the realization of my dreams.

The marriage that I once thought would bloom and grow deteriorated and eventually came crashing down to a hurtful end. I now know with everything inside of me that God's presence would have made all the difference in my life, including my marriage. During that time of my life, once again, there was no presence of God. God had nothing to do with the way I was living my life.

In spite of my unpromising circumstances, the baby I once prayed for and desired was inside of me. My focus was no longer on my failing marriage, but totally on receiving a beautiful gift—a beautiful baby girl.

ONLY TREZOREE

Because of my unhappy marriage, I chose at this time to focus only on the one thing that I knew was going to bring me happiness. That focus was on the birth of my baby girl, Trezoree. Trezoree was born without any medical complications or any abnormalities. She was a healthy 7 pound and 6 ounce beautiful baby girl. Although my marriage was empty at the time of her birth, I felt more joy at this moment than I ever felt in my life.

Trezoree's birth gave me a sense of fulfillment, purpose, and now direction. Over the next couple of years I watched her grow into a beautiful toddler. She easily captured the attention of everyone she encountered. Trezoree had beautiful eyes; unlike any I've ever seen. Her eyes were small and they sparkled at times. From her birth until she was

three years of age, I watched her grow and blossom into a beautiful little princess.

Trezoree loved to go shopping with me; getting her fingernails and toenails polished were two of the fun activities we did together. Trezoree loved to dress up in fancy outfits with colorful matching shoulder purses. Getting her hair styled in big curly ponytails made her feel like a princess, which made her feel special. She really enjoyed going through her jewelry box, picking out the cutest dangling earrings to match her stunning outfits. Trezoree was such a little girlie girl. Watching her and taking part in all of her sweet antics filled my heart with so much love and happiness.

All of my daughter's toys were scattered throughout the house. If she wasn't in her room playing, she found other areas to be quite entertaining throughout the house. Corners, under tables, behind furniture, and anywhere she thought would be interesting places to play with her various toys. Her baby dolls were always dressed up in fashionable outfits and sitting prettily in different rooms throughout the house.

Trezoree was a natural cutie pie who looked adorable in whatever she wore or

whatever she was doing. Just as all three-year-olds, she was always busy and getting into things, which kept me on my toes. Trezoree loved me with everything she had inside her. At the time, she was my only reason for wanting to exist, to live. The love I felt emanating from her toward me was a love of wholeness—total joy, giving me the feeling of completeness.

I named my daughter Trezoree-Isis. As a child growing up, one of my favorite women super heroes was "Oh Mighty Isis." I watched many episodes of the show faithfully during the Saturday morning cartoon lineup. I thought she was the coolest transformational teacher ever. Oh Mighty Isis assisted in rescuing high school students after they made unwise choices. As a little girl, I loved the show and the name Isis so much. I never forgot that name and made it part of my baby's name. (I realize now in my later years that Isis was actually a mythical Egyptian goddess. Although the name sounded really cool, I now realize that I was subconsciously rejecting my God, the one and only true God. Giving my daughter a name of an idol god truly goes against the biblical commandments of God. I thank God that my ignorance in naming my daughter Isis would

not ultimately forfeit her or my entrance into Heaven and being one with Him.)

I wanted my daughter to have a unique name—unlike any other name. I thought of Trezoree because I saw her as my one and only treasure. I could have easily spelled her name Treasury (just as it's pronounced), but I decided to give it a special little twist. I really felt the name fitted her perfectly. Trezoree was everything I had prayed for; she was breathtaking and so adorable.

I fell completely in love with her and knew I was going to be the best mommy ever. Loving and taking great care of my daughter served as a catalyst for me to push myself to make major improvements in my life. I was motivated to move forward and prepare for a great future for my daughter and me.

I poured all of my love and attention into my daughter.

While still holding on to an unloving marriage, I tried to make the best out of the situation for my daughter. I knew within my heart that my marriage was not going to last and that one day I would leave the marriage and start a new life. However, at this time, I

didn't have the strength or the courage to get up and walk away. Instead of focusing on leaving, I decided to pour all of my love and attention into the love of my life—my daughter, Trezoree.

My baby girl made me feel so happy inside and her love for me gave me the feeling of wholeness. My little angel gave me a sense of worth that I never felt before.

But before long, Trezoree was no longer the little baby who woke me up and cried throughout the night. She was no longer the little baby who needed me to tiptoe down the dark hallway to comfort her. She was no longer the little baby who looked for me through the crib rails in the middle of the night. I remember how these moments made my heart melt—she depended on me to be there when she was lonely or afraid or needed a loving hug.

Our time together was so precious that it seemed like only a day passed for her to turn from a baby into a toddler then a little angel who bounced out of her bed in the morning to jump into my bed, touch my face, and give me the sweetest little kisses on my cheeks. I loved her unconditionally and never believed in a million years that our

moments shared as mother and daughter
would come to such an abrupt end.

After the doctors reviewed the results of Trezoree's blood work, they approached me. I could tell by the looks on their faces that the results revealed something horrible.

CHAPTER 3

The Unexpected

Shortly after Trezoree turned three years of age, she started having fevers that would come and go. Weeks would go by and sometimes months, and she would not experience any type of sickness.

Then Trezoree started attending an Early Learning Center where she would often come home with a cold. I thought that because she was around so many children, they were simply passing colds around to each other. I believed her immune system would get stronger being around all of the

children attending the center. Pretty normal stuff, until she had a nosebleed. I knew then something was really wrong.

I called Trezoree's doctor and we talked about all the symptoms over the phone. The doctor suggested that possibly my house was too dry and I should purchase a humidifier to put some moisture in the air. The doctor didn't seem too alarmed by Trezoree's nosebleed and this eased my mind. After purchasing the humidifier, Trezoree didn't experience another nosebleed, and I thought maybe the doctor was right.

During that same year in the summer, Trezoree had another fever, but this time it was followed with vomiting. She was actually vomiting blood. She was quickly rushed to the emergency room at the local hospital where she was immediately seen by a doctor. At the hospital the doctors who examined her immediately recommended that she have a platelet transfusion. Hearing this, I was totally confused and I started feeling numb. Fear totally engulfed me.

I knew that a much higher power had to step in.

At this moment I realized the entire situation was out of my control and I could do nothing to help Trezoree. I knew whatever was happening to her was severe; maybe even life-threatening. I was told she lost a lot of blood and she would also need a blood transfusion. I started feeling that my baby girl was about to die at any moment. As I sat there alone in the corner of the room, watching the doctors insert IVs into the small arms of my little girl, I began to cry.

I wondered what and why was this happening to my precious daughter. Suddenly I became weak and felt powerless. I felt within my soul that the doctors and whatever treatments Trezoree was receiving weren't enough.

Sitting there and waiting I felt the need to reach out to God. I believed that my daughter needed a much higher power to step into her situation and help her survive. I looked up to the heavens and began to cry out to God for help and strength to get my daughter through this terrible situation.

"Mommy, why are you crying?"

After the doctors reviewed the results of Trezoree's blood work, they approached me. I could tell by the looks on their faces that the results revealed something terrible. The lead doctor walked up to me and began to explain Trezoree's diagnosis. He said, "After reviewing Trezoree's blood work, we have diagnosed her with a cancerous form of leukemia." I immediately felt dazed and physically paralyzed as I listened to him.

I looked across the room into my daughter's little eyes and began to cry. While she rested there, weak from vomiting, she said, "Mommy, why are you crying? What's wrong?" I had no idea what to say to her. I slowly walked over to her bed, held her little hand, lowered my head and began to pray.

911 PRAYER

I began to pray, asking Jesus to please take this terrible disease away from my daughter. Prayer along with my love were the only things I could provide for her at this time.

After a long night at the hospital, the next morning several doctors approached me and explained that Trezoree would need to

stay in the hospital for a few weeks in order to receive an aggressive style of chemotherapy treatment. They wanted to get her into remission immediately. Once in remission, the doctors stated she would receive a series of chemotherapy treatments to fight off this disease.

For the next two weeks I stayed in a hotel room connected to the hospital because I didn't want to go home. I slept very little at night, waking up many times to walk to Trezoree's room to pray over her while she slept. I felt hopeless, alone, and wasn't sure who I could talk to other than God. I felt inside of me that my daughter had a long road of recovery ahead of her.

Every day for the next two weeks, I was praying for a sign of hope and assurance that everything was going to be fine. At the end of the second week in the hospital, I was told that Trezoree was finally in remission— her body was successfully responding to the chemotherapy treatments. The doctors later told me she would be able to return home.

In spite of Trezoree's joyful attitude and happiness, this was a nightmare I wanted desperately to end.

The doctors wanted to see Trezoree twice a week in the hospital for checkups and chemotherapy treatments. Over the next two weeks, Trezoree returned to her fun-loving self and she was oblivious to the life-threatening disease circulating in her body. Trezoree appeared on the surface as a normal and healthy child. No matter how normal she appeared, though, I continued to worry daily about her health. In spite of her joyful attitude and happiness, this was nightmare that I wanted desperately to end.

While going through this terrible ordeal with Trezoree, I found out I was pregnant. The timing of this pregnancy was not favorable. After hearing the news, I left the hospital consumed with thoughts of Trezoree's illness and at this time I really didn't know how to feel about the pregnancy. Now having to face two life-changing situations, I felt alone and couldn't understand why these things were happening to me at this time. With a rocky marriage and my daughter facing a deadly disease, it was extremely hard to feel anything except confusion and uncertainty about my future.

40

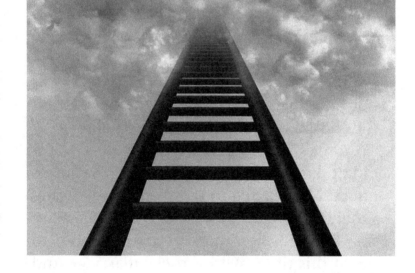

I read my Bible and meditated on many Scriptures about healing. I had faith that God was going to rescue my daughter from this terrible disease. I knew my daughter's time was running out, and I felt the entire procedure was now in God's hands.

CHAPTER 4

A Heavenly Shift

As I faced my fearful situation with my daughter, I found myself praying more. At this time in my life, even as I prayed I didn't have a strong spiritual or knowledgeable foundation with God. I really didn't understand how prayer worked or how to go about praying for a miracle for my daughter. Praying felt uncomfortable; however, I believed it was the best thing I could do to help my daughter through this dire experience. There were so many times I felt helpless

because I couldn't provide an answer for my daughter's illness.

While sitting in front of the television one day, I received a phone call from a family member I hadn't talked to for a while. Stacy, a cousin who lived in Atlanta, said, "I've been trying to get in touch with you because I heard about Trezoree's illness." I shared with her the status of Trezoree's condition and how I was barely coping with so many emotional and mental challenges. I told Stacy I was really worried, couldn't sleep at night, lost my appetite, and was trying my best not to let Trezoree see my pain or my tears.

Stacy was an awesome listener and I knew she had a relationship with God. After hearing all of my concerns and sorrows she began to talk about her faith and the power of her beliefs. She asked me if I would do something for my daughter. Stacy wanted me to pray with my daughter and pray over her daily. She wanted me to feel comfortable and confident during my times of prayer.

In the beginning I was a little uncomfortable and apprehensive because this was something that I didn't normally do with my daughter. Following Stacy's advice, though, I

prayed with a sense of urgency day and night for Trezoree's healing. Praying gave me a sense of peace and it made me feel that God was with us. Praying over my daughter, I started coping with my worries, eating more, and started sleeping throughout the night.

Stacy's phone call was a real blessing and the timing was so desperately needed. In my feelings of uncertainty, I believe God knew exactly what I needed and Stacy was His answer to my cries for direction.

WITHOUT WARNING AGAIN

During our twice-per-week hospital visits, Trezoree became very familiar with the hospital staff and many of the other children who came to receive similar chemotherapy treatments. Many doctors and nurses at the oncology center became very attached to Trezoree because of her excitement and the energy that she brought into the center.

Many of the children Trezoree and I met were diagnosed with similar forms of leukemia as her situation. Some of the children were on their last set of treatments, with a prognosis of being totally free of cancer. These situations gave me feelings of hope

that Trezoree would also be free of cancer. I often thought to myself while at the center, *This will all be over soon, and my daughter and I can get back to living happy, healthy, and normal lives.*

As I continued praying, I often felt if I had an earlier prayer life with God, this situation would not have happened. Many times I had a feeling of being "behind in my prayer life," and I questioned if God was really listening or willing to answer my prayers. Confused about my relationship with God, I wondered if asking Him for a miracle for my daughter was conceivable. Having doubts and coupled with fears, I felt a sense of crisis with my prayers and my relationship with God. Although fears settled in, I continued to pray and ask God to help me and get my daughter completely out of this terrible ordeal.

Sitting at home one evening, Trezoree became very ill and complained of stomach pain. I rushed her to the hospital fearing the worst. When we got there, her doctor immediately took her into the examining room. During her examination, the doctor took blood samples. After the doctor's examination I sat by the bed and held Trezoree's hand. Sitting there I didn't know what to

think. About ten minutes later the doctor returned and asked me to come with her for a meeting in her office. In her office she explained to me that Trezoree's leukemia that was in remission had returned—and this time it appeared to be worse than before.

In crisis mode again, I desperately needed God to help us.

The doctor said, "If we don't respond to this quickly, Trezoree could die." At that moment, I was terrified about the possibility of losing my daughter forever. She also explained that Trezoree needed a more aggressive type of treatment to get her back into remission before they could proceed with any additional steps. She then said, "Once Trezoree is back into remission, she will need to receive a bone marrow transplant which would produce new and healthy blood cells."

As the doctor gave me all this information, I asked questions about the full procedure of a bone marrow transplant. The doctor gave me her best way of explaining the procedure and how it could help

my daughter in her fight against leukemia. Stunned by the process of these new treatments I begin to feel dazed and needed to get some fresh air to register all of the new information.

After receiving another session of chemotherapy, I was hoping Trezoree would go back into remission. Her hair fell out because of the treatments and sores appeared on her feet along with burn marks all over her body. My heart was torn watching my daughter go through the process of chemotherapy. Although all this trauma was happening to her fragile little body, she continued to laugh and play with her baby dolls in her bedroom as if nothing out of the ordinary was going on. There were many times when I stood near her or watched her with a smile, while at the same time feeling my heart ripping apart inside me. I never wanted Trezoree to feel or see the pain I had running through my body.

FEARING THE UNKNOWN

By now I was in my ninth month of pregnancy and my stress had reached an all-time high. Being pregnant and unsure

about what's going to happen to Trezoree prevented me from sleeping at night, and sometimes I suffered through hours of anxiety.

Then I was told by Trezoree's doctors that my unborn baby could possibly be a perfect match for Trezoree's bone marrow transplant. They explained to me that I would need an amniocentesis procedure done to find out if my unborn baby would be a match. The procedure consisted of a needle being inserted into my belly area to extract amniotic fluid and cells from the baby. I was totally terrified and worried about the entire procedure.

With my family being optimistic and the doctors feeling very hopeful, I really believed that the procedure was going to help Trezoree. The night before the procedure I couldn't sleep; however, I believed the baby I carried inside me would be a perfect match for Trezoree's bone marrow transplant.

The following morning as I went to have the procedure, I felt nervous and afraid and doomed to a painful procedure. I remember sitting in the examination room and the doctor took out the longest needled I have ever seen. The doctor explained to me once

again that he was going to extract some amniotic fluid from the baby and he also stated that the procedure wasn't as bad as it appeared.

The very next day I went back to the hospital to discuss the results with the doctors and was told that the test revealed negative results. I was devastated. I was told that the results were not even close to being a match for Trezoree.

Trezoree tenderly loved her new little baby brother.

A few weeks later my son was born, and I really wasn't focused on his birth as much as I wanted to be. My mind was so engulfed with Trezoree's health that I wasn't able to transition my feelings and emotions to the birth the way I wanted to for my son's arrival.

After being in the hospital for three days with my new baby, I was excited about Trezoree meeting him. Sitting in the passenger seat on the way home from the hospital, I remember thinking about how was I going to take care of my new baby along with Trezoree's situation. When we got home, I opened the door and Trezoree quickly ran

out of her bedroom to meet her new baby brother. She was really excited and wanted to see his face and hold him. She became consumed with his presence.

Often while he slept, she brought toys near his crib and played beside him. He was her newfound best friend. I really enjoyed watching Trezoree's immediate connection with her baby brother. Although I was happy to see her happy, I continued to pray and hope that some positive news would come regarding her health.

Hope!

The very next week I received a call from Trezoree's doctor and I could hear some excitement in her voice. She told me that my daughter had responded once again to the treatment and she was back in remission. Her doctor from this point felt that it was necessary to quickly place Trezoree on a bone marrow registry. She wanted me to know that a successful bone marrow transplant was Trezoree's only option for a full recovery from this disease.

Days I waited for a phone call regarding a match for Trezoree. It took a little over two

weeks before I received a call that there was a perfect match identified for my daughter. The very next morning we went to the hospital so Trezoree could be examined and start preparation for her bone marrow transplant.

I was told the procedure consisted of the donor being flown in from out of town and once the donor arrived, Trezoree would then receive a much stronger dose of chemotherapy treatment. This dosage would completely kill any cancer cells and all healthy bone marrow that remains. New bone marrow would then be inserted, allowing new stem cells to grow in the bone marrow. I was really excited that this person was a match for my daughter and many of the staff members at the hospital were excited as well.

CRYING OUT TO GOD

I prayed often while waiting for the bone marrow procedure to take place. My prayer life was more consistent, and I felt my relationship with God had grown more during my daughter's illness. I read my Bible and meditated on many Scriptures about healing. I had faith that God was going to rescue my daughter from this terrible disease. I

knew my daughter's time was running out, and I felt the entire procedure was now in God's hands.

The very next morning, Trezoree's doctor came into her room with a painful look on her face. She stated that Trezoree had relapsed and would not be able to receive the bone marrow transplant. She also said that due to her relapse, there was nothing else they could do for her. This included the chemotherapy treatment, which ultimately meant that my daughter was not going to survive.

"What's next for my daughter?"

My conversation with the doctor then turned to asking her what was next for my daughter. I was told she would be cared for in the hospital and made comfortable during the rest of her stay. Her doctor also stated that she wouldn't have long to live.

I did not want my daughter to die in the hospital; I told the doctors I would rather she spend her last moments at home with me. The doctors told me in order for her to go home with me I would need special care equipment and resources from the hospital.

In addition to the resources at the hospital, I was also told that she would need a nurse. Her doctors told me she was "high risk" and was considered an intensive care patient.

Her doctors told me that they would do their best to assist me in getting Trezoree home. Throughout that day my daughter's health rapidly declined. Later that evening while Trezoree was sleeping, I held her hand and said a prayer, understanding that she would soon leave me. Many times throughout the night her nurse came in and checked her vital signs. It was extremely hard for me to sleep; there were many times I dozed off for minutes at a time and awakened with fears that Trezoree would no longer be with me.

The very next morning Trezoree appeared to be in a coma-like state and would no longer respond to my voice or touch. Her medical team came in to check her and told me her vital signs were dropping quickly. They then advised me to immediately call my family and friends because Trezoree probably had only a couple of hours to live. I felt a sense of urgency and immediately called my family and my closest friends. Within an hour my daughter's room was filled to capacity. Everyone

stood around us weeping and watching me and my baby while I held her hand. Sitting next to her bedside, I continued to kiss and hold her hand while understanding that she was about to make a heavenly shift as she took her last breaths.

My thoughts and trust turned completely to God because He was about to take possession of my one true love. This was indeed my breaking point. The one thing that I had totally feared was now upon me and the one person I truly loved was about to depart from me.

> **God was about to take possession of my one true love.**

THE SELFISH ME...

After Trezoree's death I looked to God for guidance even though I still struggled with her no longer being part of my life. There were times I wanted to call it quits, even considering the possibility of ending my life. Many times I went through feelings of emptiness and I saw no reason to go on. In my mind everything around me was decaying. I was trapped in a jar of hopelessness that was

sealed with a tight lid. I summed up my life to be one filled with sadness and many sorrows. The great loss I felt was too much to handle and I felt overwhelmed with grief.

But...I knew deep down inside I could never allow myself to sink to a level where I could possibly end my life. I knew I had to muster up some strength to push forward and believe in the possibility of life after death. What else was there for me to believe? Was I to believe that my daughter was dead and that was it? If that was all there was, then, yes my life should have ended along with hers.

I decided to take courage and believe that there was more to Trezoree's story and more to my life. I started moving forward into another dimension of thinking and believing in God's Word.

> I completely turned my sights to God, the Creator of all.

I completely turned my sights to God, the Creator of all. Scripture tells us in John 3:16 (AMPC):

> *For God so greatly loved and dearly prized the world that He [even] gave up His only begotten* (unique) *Son, so that whoever believes*

in (trusts in, clings to, relies on) *Him shall not perish* (come to destruction, be lost) *but have eternal* (everlasting) *life.*

After reading John 3:16, this gave me the peace that my unsettled mind could not provide. I knew that my daughter's life had a new beginning with an eternal home. This Scripture gave me faith that one day I would reach this same eternal heavenly home and be with my daughter. Isaiah 26:3-4 also provided me perfect and constant peace.

> *You will guard him and keep him in perfect and constant peace whose mind [both its inclination and its character] is stayed on You, because he commits himself to You, leans on You, and hopes confidently in You. So trust in the Lord* (commit yourself to Him, lean on Him, hope confidently in Him) *forever; for the Lord God is an everlasting Rock [the Rock of Ages]* (Isaiah 26:3-4 AMPC).

Think of Heaven as God's "Safe Deposit Box" for your deceased loved ones who have accepted Jesus Christ as their Lord and Savior. Think of them as a deposit into God's safekeeping where they are being kept and secured until you meet up with them again.

CHAPTER 5

God's Safe Deposit Box

Thinking back on the day of my daughter's death, I recalled myself walking out of her hospital room, going to the ladies' room, and praying to God. I had to believe that my daughter was now with Him in Heaven. I knew at this time my faith had to shift in the direction of receiving God's promises.

At that time I told myself I needed to do everything humanly possible to get closer to God if ever there was a chance of seeing my daughter again. Looking back I remember leaving the hospital with a numb feeling,

but in my mind I was driven to seek God for more answers. I knew that if Trezoree was in Heaven, I was going to find out everything I could about her new home. I knew there was work to be done. I had to erase all of the past thoughts in my mind about natural life and begin a spiritual life with God. I was determined to connect with God and receive guidance about this new life and knowledge on how to cope with my daughter's early departure.

GOD'S DREAM OF ASSURANCE

Eleven days after my daughter's passing I had a dream. In this dream I was being led into a big mansion. While standing in this huge home, I was approached by someone who spoke softly and told me that Trezoree was upstairs and she wanted me to know that she was okay. A feeling of excitement overtook me and I pleaded to see her. I was told to look toward the top of the staircase, and as I turned my head I saw Trezoree slowly walking down the steps holding someone's hand.

I immediately noticed that her feet that were once covered with sores from the

chemotherapy treatments were completely healed. I also noticed that her hand on the railing was free of blisters and burn marks that she also endured with the treatments. She then stopped on the staircase and stood there smiling at me. I ran up the stairs, gently grabbed her beautiful little hands and began kissing and rubbing them and then I held her perfectly healed feet. I marveled that her entire body was free of burns and marks. As Trezoree stood there holding the person's hand, she continued to smile as she saw how I was overwhelmed with happiness.

I could see she was happy and completely healed.

I was so overjoyed and excited; I began to cry and asked her if she was okay and what kind of place was this. She never answered any of my questions, she only smiled. After she glanced at the person who was holding her hand, she looked back at me with a smile that told me she was completely healed, safe, and very happy. Her smile was totally comforting, gave me peace, and I knew in my heart that she was okay.

I awakened and was convinced that this dream was from God. I believed there was a message in this dream—that Heaven is indeed real and there is assurance that my daughter is now residing in a place full of comfort and peace. This dream from God was confirmation for me and now I had new strength to move forward with my life.

From this point on, I began consistently studying and reading God's Word, the Bible. I wanted to know everything about God and my daughter's new home. I knew Trezoree could never return to me; however, I knew giving my life to Jesus Christ and having a true relationship with God was the answer to an everlasting life with Him and my daughter.

> *Let not your heart be troubled; you believe in God, believe also in Me. In My Father's house are many mansions; if it were not so, I would have told you. I go to prepare a place for you. And if I go and prepare a place for you, I will come again and receive you to Myself; that where I am, there you may be also. And where I go you know, and the way you know* (John 14:1-4 NKJV).

Knowing that my daughter is in God's safekeeping, my thoughts completely shifted

from mourning, hopelessness, and feelings of uncertainty to thoughts of joy, healing, and certainty of God's love. After looking back at my life and all the mistakes I made, I realized it was time for me to live right with God and make every second of my life count.

GETTING RIGHT WITH GOD

The Bible tells us in Ephesians 2:8-9 that our salvation cannot be earned. Meaning, I would not be able to see my daughter again based on how I lived or just by being a good person. I would only be able to see my daughter again by accepting Jesus's sacrificial death for remission of my sins, and thereby become spiritually born again. Only then would Jesus take over my life; and because He is in Heaven, I would be where He resides when my time on earth ends.

I was obligated to show God that I love Him and that I wanted to hold myself accountable and live a godly life. Feeling sorrowful and confused about my daughter's death was no longer an option because now I knew better. It was now time to function and operate under God's government, His principles, and His jurisdiction.

Losing a loved one often places many of us into an awful grieving period. We make mistakes, do things out of character, and blame it on the loss of our loved ones. We use this grieving period to make excuses for our mistakes and for not moving forward in our lives. Ultimately, many of us use our loved one's death as a standstill position in life.

THOUGHT-PROVOKING QUESTIONS

If you have lost a loved one, if you knew that your loved one had repented of his or her sins and accepted Jesus Christ as Lord and Savior (keeping in mind that children younger than the age of reason, not knowing right from wrong are automatically saved), were saved and had everlasting life with God, would you do anything differently in your life?

How would you respond knowing this about your loved one? Would you make a significant change in your life with God? Accepting Jesus Christ as your Lord and Savior is the only way to receive what your loved one has received through reciting the prayer of salvation. How important is it to you to

have a relationship with God, knowing that this relationship will provide you with ever-lasting life and the wonderful opportunity of reconnecting with your loved one?

Think of Heaven as God's "Safe Deposit Box" for your deceased loved ones who have accepted Jesus Christ as their Lord and Savior. Think of them as a deposit into God's safekeeping where they are being kept and secured until you meet up with them again. A safe deposit box is a place where you keep your most valuable possessions. Seeing your deceased loved ones as your most valuable possessions and having them placed in a safe, protected environment should immediately ease your mind. Feelings of sorrow and hopelessness should no longer be your focus. Knowing that they're safe, you can now allow God to bring peace in your life, protection, and His endless comfort.

> I completely turned my life around to seek after God so I can see Trezoree again.

My daughter was everything to me. I cherished every moment we spent together; and now that she's with God, I have com-pletely turned my life around to secure

an opportunity to be with her again. In essence, Trezoree's death has provided me with a relationship with God; a relationship that may not have come into existence if she was still alive today. Realizing this later, because of her death, I have been given the opportunity to have an eternal, everlasting life with God.

Increasing my relationship with God through His Son and receiving the Holy Spirit has secured a place for me in Heaven. Now that my salvation is guaranteed, my place in Heaven is secured and I know one day I will see my daughter again.

I truly believe as long as God is the driving force in my life and the focal point of my daily routines, here on earth my life will consist of abundance and happiness until it's time to be with Him and Trezoree in Heaven. Reading my Bible and understanding God is now my newfound love and my new way life.

I understand that marriage is honorable before God and divorce isn't, but in some situations I decided to let God be the judge. I decided to pack up my belongings and my three-month-old baby and leave. I needed to find peace, happiness, and normalcy in my life.

CHAPTER 6

Modification of Life

Losing Trezoree was the toughest thing I've ever gone through. The second toughest thing was moving on and ending a marriage where there was no love. Having feared the uncertainty of completely starting over was one obstacle I hadn't planned for. However, I knew deep down inside I needed to have courage and move forward in my new life.

I questioned my thoughts often, but I knew that my marriage was unhealthy and I needed to move on. Unfortunately, that change meant exiting the marriage.

Reminiscing over my daughter's death and my huge growth in my relationship with God, I felt moving on was the best thing to do. I understand that marriage is honorable before God and divorce isn't, but in some situations I decided to let God be the judge. I decided to pack up my belongings and my three-month-old baby and leave. I needed to find peace, happiness, and normalcy in my life.

As I started my new journey as a single mom, there were many times I second guessed myself and wondered if I had made the right decision. During this time of separation, many positive things occurred in my life through God. A new home, increase in my job, peace of mind, and my relationship with God was flourishing beautifully. But there was always the thought of not being in a proper setting of marriage for my son and me.

RECONCILIATION TO DEVASTATION

Two years later, I was still separated and still married. I had many thoughts of reconciliation over those two years, so I decided to give my marriage another chance,

hoping that we could become a healthy family. Within a short time I became pregnant with my second son. One month into the pregnancy, things became terrible and frightening. I questioned whether I had done the right thing in reconciling with my husband.

There were times in the marriage I feared for me and my child's well-being. I knew I had to leave permanently and never look back. One night I cried out to God as I fell to my knees. I asked God for forgiveness and direction for what I was facing. I went through my third pregnancy totally alone—except for God, who promises in the Bible to never leave us. My mind stayed focused on God's Word, and I relied on Him for instructions and clarity in my life.

Three months after my second son was born, my divorce was final and I finally felt free to move forward with a godly, purpose-driven life.

As I sought God daily, He gave me complete comfort, peace, and strength.

As my life moved forward, there were times I was still saddened about Trezoree's death. I knew that the healing process was on-going. God was always there to remind me that He was with me through these moments of insecurity.

Having the job of raising two children kept me busy, occupied, and also helped me through tough times whenever I thought about Trezoree. Daily my relationship with God became more comfortable and through it I received the strength that I needed to move forward.

Many times I received revelations from God about Trezoree. He often reminded me of the dream I had about meeting Trezoree in Heaven. The dream reminded me of my visit with her and how beautifully at peace she was. The thought in itself was enough to pick me up and keep me happy in the present moment and looking forward to the future. The thoughts of going to Heaven and seeing my God with my daughter gave me an awesome feeling of joy.

THE UNBELIEVING ME...

There were times I was tempted to allow the devil to place me in situations that were against all that I've accomplished in my relationship with God. I struggled at times with worldly and material temptations in life. During those times I heard God whispering in my ear about what I needed. I felt He was reminding me to stay in His Word and keep it at the forefront of my life. His messages came to me daily in different forms; spiritual teachings from television, inspirational music, and a library of inspiring DVDs that were based on His principles.

A new life required a new way of living, thinking, and believing.

I knew there was always more that I could learn in my walk with God. My new life with God required many new ways of thinking. Many verses throughout the Bible came into my mind in my study time. Whenever I needed a verse for encouragement, many times I would turn to the index in the back of my Bible. The index was very helpful in finding words that pertain to my situations. Utilizing the Bible's index was, and is, a great tool for healing and restoring my faith in times of temptation.

For instance, the Bible tells us in Ephesians 6:11-18 (NIV):

"Put on the full armor of God, so that you can take your stand against the devil's schemes. For our struggle is not against flesh and blood, but against the rulers, against the authorities, against the powers of this dark world and against the spiritual forces of evil in the heavenly realms. Therefore put on the full armor of God, so that when the day of evil comes, you may be able to stand your ground, and after you have done everything, to stand. Stand firm then, with the belt of truth buckled around your waist, with the breastplate of righteousness in place, and with your feet fitted with the readiness that comes from the gospel of peace. In addition to all this, take up the shield of faith, with which you can extinguish all the flaming arrows of the evil one. Take the helmet of salvation and the sword of the Spirit, which is the word of God. And pray in the Spirit on all occasions with all kinds of prayers and requests. With this in mind, be alert and always keep on praying for all the Lord's people."

We must continuously fight to keep our minds sharp, protected and in a safe place away from mental agony. You must realize that worldly heartaches are designed to exclusively overtake you and make you feel powerless and ineffective in every area of your life.

CHAPTER 7

Triumph or Tragedy

Grieving over the loss of a loved one can be very hard and most times unbearable—especially if the loss is a child. Oftentimes we make our loss a situation that we allow to play over and over again in our minds. We are haunted by the loss and allow dismal thoughts to attach to a series of regrets. We tell ourselves things like, "If I had only loved her or him more, this would not have happened. If I'd been around more, I could have controlled the situation." Or, "If I

would have made the right choices or decisions, she or he would still be alive and with me today."

The truth of the matter is, good and bad things happen to everyone. Many times those occurrences have absolutely nothing to do with us or what we could have done differently to change the outcome. Knowing and believing this doesn't take away the pain of our loss, however it can assist us in moving forward and getting past our current state of regret and hopelessness.

Good and bad things happen, and many times they have absolutely nothing to do with us.

Unfortunately, we're living in perilous times. Many of us are emotionally, physically, and some of us are even spiritually drained. In many situations our minds are consistently being challenged emotionally to a point where we often have feelings of giving up. Long days of everyday living can be physically challenging. Some of us struggling spiritually are constantly faced with temptations of the world. These challenges are not uncommon and we need to tell ourselves this is not the time to quit. We must

continuously fight to keep our minds sharp, protected and in a safe place away from mental agony. You must realize that worldly heartaches are designed to exclusively over-take you and make you feel powerless and ineffective in every area of your life.

RECKLESSNESS OR PRAYER

When my four-year-old daughter died, my initial thoughts were of recklessness. I truly believed that my life was over. I had to make lifesaving decisions.

Instead of giving up on life, I started embracing the reality of life after death. I began to pray out loud, believing that my precious daughter's life was now in God's hands. I continued my prayer by adding, "Since I'm choosing to believe where my daughter is, I'm now totally trusting in You. I will do everything in my power to live right and to get to where she is." I basically told God, *"I'm coming after her."*

Instead of giving up on life, I started embracing the reality of life after death.

We must realize there are things we must do when we give our lives to God. Reading and studying His Word daily can guide us through any situation. While researching in the Bible, it was revealed to me many times that God resides in Heaven, but He also lives in every born-again child of His. It is this spiritual rebirth that guarantees us all that one day we shall see our saved, departed loved ones.

> **I found my heavenly Father to be very much alive and residing not only in a real home called Heaven, but also in the hearts of His children.**

In the Living Bible, First Corinthians 2:10-12 tells us:

> *"But we know about these things because God has sent his Spirit to tell us, and his Spirit searches out and shows us all of God's deepest secrets. No one can really know what anyone else is thinking or what he is really like except that person himself. And no one can know God's thoughts except God's own Spirit. And God has actually given us his Spirit* (not the world's spirit) *to tell us about the wonderful free gifts of grace and blessing that God has given us."*

The more I read and stayed in God's Word, the more His Word began to speak back to me. I was finally free, and now I could live my life in peace and in confidence, knowing that my daughter was very much alive and residing in a place called Heaven.

HEAVEN IS REAL

Throughout this book I write about my personal experience in dealing with my daughter's death. I want to assure you that Heaven is real, your *born-again*[1] child or loved ones may have left this world, but they are safely residing in Heaven with God.

I challenge you to read the remainder of *Heaven's Playground* with an open mind. I would also ask you to challenge yourself by asking the following two questions:

> *If I die today or tomorrow, where will I ultimately end up?*

> *If my child or loved ones are alive, safe, and in Heaven, have I done everything in my power to get to where they are?*

The Bible tells us that you must give your life completely to Christ. When you do this, your life becomes His life. He will then see to it that you have an abundant earthly life and an eternal perfect life.

You can have a life with God full of love and abundance *now* if you take the steps that He has provided for you. The choice is yours to make. Living your life with God's purpose as a goal is the way to your happiness, prosperity, and your new beginning. I promise you—not only will you see your child or loved ones again, you will receive God's very best in every area of your life.

Endnote

1. "Born again" means to be spiritually renewed, someone who has received salvation and has made a firm commitment of faith.

Just as the spirit of your saved family member is now in God's safekeeping, so is the spirit of the child who didn't make it full term, or was born and then died.

CHAPTER 8

The Unborn Loved One

Being pregnant and anticipating your baby's arrival is a very delicate and exciting time for expecting mothers. The moment you're aware of being pregnant, you instantly become attached to the unborn child who is developing inside you. Most parents begin to love their unborn baby immediately and unconditionally. Most start planning for the baby's future right away: creating a nursery, choosing a name, scheduling doctor visits, and friends usually plan a baby shower to provide needed items. These are just a few

of the ways people plan for their child's arrival—what most expecting parents enjoy doing in anticipation.

Unfortunately, in some cases an unborn child does not survive through the entire pregnancy. And sometimes the baby is born but dies shortly after birth. The death of a child at any stage triggers a traumatic emotional letdown that affects both expecting parents.

Perhaps you were forced to make the decision to abort your child. This decision may have been the result of an unwanted pregnancy due to family issues or other reasons that may have been out of your control. You may have received a report from the doctor stating that the embryo growing inside you was about to die or had health complications. Unfortunately, some women have been victims of rape and became pregnant and chose to terminate the pregnancy. Whatever the reason, the pregnancy and the life of the child conceived was ended.

Many times in life we are faced with making hard decisions. The one thing you must consider is that the baby (or embryo) inside you has a soul and a spirit. Whether you gave birth to that child or not, the soul and spirit

of that child was alive and the spirit is still alive with God. Just as the spirit of your saved family member is now in God's safekeeping, so is the spirit of the child who didn't make it full term, or was born and then died. Just as you've received revelation about where your saved loved ones are, you should also apply that same revelation toward the life that was once inside you.

> **If you feel guilty about terminating a pregnancy or having a miscarriage, I encourage you to let go of that guilt. Your baby is in Heaven, waiting to see you again.**

If you've ever felt guilty about a decision you made regarding terminating a pregnancy or giving birth to a dead child, I encourage you to now let it go. You can pick yourself up from this experience and move on. God has your child now and the child is waiting for you in Heaven. Knowing this, would you be willing to change your life and seek God? It doesn't matter how or why your baby died. The most important thing you must understand is that your child is now in God's safekeeping, waiting on the other side, and longing to be reunited with you.

THE PLAYGROUND IN HEAVEN

I remember some years ago watching a man on television talk about his encounter with God in Heaven. He spoke about his dream that he experienced with God regarding the lost lives of babies and children. He described how, in his dream, he saw groups of all kinds of children playing, laughing, and enjoying themselves in Heaven. He noticed that the children were divided into groups according to the fatalities or illnesses that ended their lives on earth. All of the children were innocent and lost their lives unexpectedly well before their time.

As the man telling the story continued to walk through this beautiful place he knew was Heaven, he was totally overwhelmed by the joy, peace, and happiness of the all the children he saw. Then he noticed in particular a group of children to his far right. This group of children looked perfect, perfectly happy and peaceful. He said he *"was able to determine what had happened to the previous children but was unable to determine the illnesses of this group of children."* He decided to ask God, *"Why are these children here? They look perfect in*

every manner." God answered, *"These are all My aborted children. Their parents didn't want them, but they are still alive and they're now with Me."*

After watching this segment on television, I realized that the choices people make to terminate their pregnancy or if a child dies unexpectedly will not negate God's ultimate plan of holding a place for the child's spirit. Your unborn baby is very much alive, filled with peace, happiness, contentment, and joy.

Your unborn baby is very much alive, filled with peace, happiness, contentment, and joy.

If you can visualize your unborn baby laughing, singing, and dancing around in Heaven, it should bring you overwhelming peace in your life. You can now let go of your past feelings of hurt and regret. Take hope in knowing that your unborn baby is safe, secure, and waiting to meet you. Your child is now in God's "Safe Deposit Box."

"There is therefore now no condemnation to those who are in Christ Jesus, who do not walk according to the flesh, but according to the Spirit. For the law of the Spirit of life in Christ Jesus had made me free from the law

of sin and death," (Romans 8:1-2 NKJV).

Once you confess your sins and give your life over to Christ you are a new creature; all things have been renewed. You no longer have to hold on to your past mistakes or regrets. God loves you and will never condemn you for something that He has forgiven. Completely trust in His love and believe you are forgiven for your sins and you'll be free to live, love, and enjoy your life again.

THE REGRETFUL ME...

Experiencing death through the loss of my child was devastating. I often blamed myself for everything that happened to her. I wondered if my past mistakes and sins had anything to do with her death. At times I felt it was much easier to believe that I was being punished by God instead of believing that Trezoree's death was just one unfortunate situation.

Thoughts of condemnation do *not* come from God—they come from the devil.

After reading Scriptures and loading my mind with God's Word, I soon realized that blaming myself for Trezoree's death was keeping me in bondage and was preventing me from experiencing the liberty to be at peace and move forward with my life.

> **Forgiving yourself for past mistakes allows you to approach God freely and ask Him for a new beginning.**

Forgiving myself for my past mistakes allowed me to approach God freely and ask Him for a new beginning. Believing and knowing that all things are new with God gave me permission to live life blamelessly, free and without fault.

When you realize what Heaven is and receive a clear revelation of what God has in store for you, your life will never be the same.

CHAPTER 9

Securing Your Place in Heaven

"So here's what I want you to do, God helping you: Take your everyday, ordinary life-your sleeping, eating, going-to-work, and walking-around life—and place it before God as an offering. Embracing what God does for you is the best thing you can do for him. Don't become so well-adjusted to your culture that you fit into it without even thinking. Instead, fix your attention on God. You'll be changed from the inside out. Readily recognize what he wants from

*you, and quickly respond to it. Unlike the culture around you, always dragging you down to its level of immaturity, **God brings the best out of you,** develops well-formed maturity in you,"* (Romans 12:2 MSG).

Making up your mind to do something and then doing it can have an ending of gratification. Knowing that your child or loved ones are with God and their place is secured in Heaven, what would you do next in your life? If God does not exist in your life, would you be willing to make the transformation?

When Trezoree died, God made it very clear to me where she was. He made it clear to me that she was safe, happy, and free of leukemia. Knowing that she was safe and secure in Heaven gave me peace—and finally a feeling of rest.

When I accepted God's free gift of salvation, the Holy Spirit was free to move inside me and set me on a course led by God's principles. With the help of the Holy Spirit guiding me, I was able to follow God's blueprint and seek admittance into His heavenly domain. Having the Holy Spirit working in me, I was able to grow and develop into the image of Jesus Christ.

Accepting Jesus Christ as my Lord and Savior required me to make many changes in my life, including where I went, the people around me, the activities in which I was involved, and the music I listened to. I watched and grew as the Holy Spirit gradually made positive changes in me. I praised God every step of the way and thanked Him for removing things that were detrimental to my growth. The removal of unhealthy aspects of my life played a major role in where I was headed and who I would eventually become.

> The Holy Spirit gradually made changes in me, and I praised God every step of the way.

Having a new destiny in life and desperately working toward seeing my daughter was my main focus. At this point, my perception of life had truly changed. I sensed on many occasions that people thought I had gone into a state of weird depression when I lost my daughter. I'm almost sure that many perceived me as a spooky, deep, spiritual chick. I really didn't care what people thought, my mind was being renewed and my life was being restored. The fact of the

matter was I heard from God and Trezoree was secure. Most people around me at that time did not realize I had acquired a *passion for learning about God.*

When you realize what Heaven is and receive a clear revelation of what God has in store for you, your life will never be same. Changes in my daily routine had purpose and allowed me to have order in my life with God. Praying and trusting in God gave me power and control that helped me through whatever I needed to achieve. My prayer life was very important, trusting in what I prayed for and anticipating God's response was based on trust, faith, and boldly walking into any situation with confidence.

The excitement of my transformation gave my life a solid ground to stand on. I knew transforming my mind, my heart, and my soul would allow new information to grow within me.

Over and done with my past, the future became incredibly bright for me. With God's help I truly became a new me. Gaining His wisdom in everyday situations allowed me to handle and process each new circumstance with clarity. Be it opportunities, new asso-ciates, my children, or everyday decisions,

I was able to calculate and approach them with confidence. Making sure I was listening to God's voice was crucial. I had to figure out the difference between hearing me and hearing Him. Staying in God's Word helped me distinguish the difference between my voice and His voice.

Many times we make the mistake of following our feelings instead of receiving the voice of instruction from God. We may allow our emotions to get the best of us. In my situation, my daughter's death involved so much of my feelings and emotions it was very hard to pay close attention to what direction God was sending me.

You have to trust God and believe His plan for you is perfect. Don't second guess an instruction from God with your own intellect.

At this point in my life, I realized that my journey with God was filled with progress. I truly believe God was preparing me for something much greater in life. Each day I woke up with the anticipation of doing what was right in God's eyes. No matter what the situation was, I believe through the inspiration of the Holy Spirit, direction would come to me. I knew God was watching me

and leaning on the Holy Spirit kept me from making careless, unwise decisions.

> **Make every moment of your life count—what you say, do, think about, and study are extremely important.**

It is so important to continuously prepare yourself with God's Word for your everyday living. With all of the distractions here on earth, you can easily find yourself slipping back into your previous life. Make every moment in your life count. What you say, do, think about, and study are extremely important in accessing the Kingdom of God.

The Bible tells us:

"So be careful how you live. Don't live like fools, but like those who are wise. Make the most of every opportunity in these evil days. Don't act thoughtlessly, but understand what the Lord wants you to do. Don't be drunk with wine, because that will ruin your life. Instead, be filled with the Holy Spirit, singing psalms and hymns and spiritual songs among yourselves, and making music to the Lord in your hearts. And give thanks for everything to God the Father in the name of our Lord Jesus Christ," (Ephesians 5:15-20).

A Quest for God

Many of us look for happiness in all the wrong places as we walk through life: relationships, job opportunities, or material possessions are just a few wrong places that bring only temporary satisfaction, if any. Seeking God first in your quest for happiness will give your plans purpose. Not seeking Him first only open doors of regret, sorrow, and possible set-backs.

Grieving over the loss of loved ones can cause you to seek unhealthy areas of comfort in your quest for relief. Staying grounded in God's Word and meditating on the promises of God will bring the comfort and relief you're desperately looking for. Staying committed and having consistency will improve your journey with God.

Having commitment and consistency, God began to reveal so many wonderful things to me about myself. Having identity, feeling special, and recognizing my worth and value as a woman were new revelations in my life. I find it amazing to realize now, after so many years, that much of my life was in total darkness. Unfortunately, it took my daughter's death to light my way so I could

make the changes needed for me to have a clear revelation of who God is.

I now wake up every day excited about my life—ready and willing to give God 100 percent of my love and commitment. Understanding that Trezoree is in Heaven and waiting for me creates a special feeling daily. Making sure my heart is true and securing my place in Heaven is worth the journey to see my special Trezoree again.

THE UNSETTLED ME...

In some journeys we come across areas where there are bumps in the road. In my journey through Trezoree's death, I questioned my faith many times. I knew I was going through a process of believing in God and trusting Him in knowing where my daughter was. The unsettled part in me was the challenge to accept what God was showing me. Believing in the unknown was difficult, and many times I questioned myself. I needed to recognize that I was now a different person, and in order for me to receive God's promises I had to have blind faith.

The person I was and the path I was on may have seemed strange to many. Understanding that God was transforming me was something I needed to receive daily. In my reading of the Word, I realized what God did for Joseph, Job, King David, Esther, and many others. These were faithful men and women of God who trusted Him and knew Him to be true to His word. I knew then that my faith was the key to activating the promises of God.

There will be times when everything around you is falling apart. It is during those times when you must trust in God and believe within yourself that things will get better and that you will see a new day and be fully restored.

CHAPTER 10

Beauty for Your Ashes

We all lose loved ones throughout our lives and go through periods of mourning and despair. But excessive mourning can cause more damage in your life and postpone the work of God's healing. Having lost a loved one is truly not the end of your story. Staying in faith and realizing God will give you beauty for your ashes is in your future.

I'm reminded of a story in Second Samuel 12 when the prophet Nathan rebukes King David for arranging the killing of his soldier, Uriah the Hittite, and then taking

his wife, Bathsheba, as his own. King David committed adultery with his soldier's wife and she became pregnant with the king's baby.

To cover up the scandal, King David arranged for Bathsheba's husband to be killed in a battle. After Bathsheba's husband was dead, King David could proceed with his marriage to Bathsheba. King David married Bathsheba and loved the baby that she carried inside her.

King David's prophet, Nathan, came to visit the king and informed him that the Lord knew about his sin and that he would be severely punished. Nathan the prophet told King David that he would not die and that the Lord would not kill him, but the baby Bathsheba carried would surely die. Days after Bathsheba delivered her child, the baby became ill.

While the child was still alive, King David pleaded with God for the child. He fasted and spent nights lying in sackcloth on the ground. The elders in his household could not get him up off the ground, and he refused to eat any food. On the seventh day the child died. The elders informed King David of the child's death. King David got

up from the ground, washed, put on lotions, changed his clothes, and went into the house of the Lord to worship. He then went to his own house and requested that his servants serve him food.

His servants questioned him and asked, *"Why are you acting this way? While the child was alive, you fasted and wept, but now that the child is dead, you get up and eat!"* King David answered profoundly, *"While the child was still alive, I fasted and wept. I thought, 'Who knows? The Lord may be gracious to me and let the child live.' But now that he is dead, why should I go on fasting [mourning and grieving]? Can I bring him back again? I will go to him, but he will not return to me,"* (See 2 Samuel 12:20-23 NIV.)

David, a man after God's own heart, grieved for his son, then got back up and began living normally again.

The story goes on to say that King David went to comfort his wife, Bathsheba, and continued to love her. She got pregnant again and gave birth to another son whom they named Solomon. The Scriptures go on to say that the Lord loved Solomon.

After reading this story in the Bible, it spoke back to me on so many levels. King David committed an awful sin and was punished for it. He grieved during an appropriate period of time and then began living normally again. He then made a profound statement, *"I will go to him, but he will not return to me."* King David clearly knew that his baby was now in Heaven with the Lord. He knew that his baby did not live long enough to attain the age of reason (knowledge of good and evil), and was automatically taken to Heaven upon his death.

King David also knew that the only thing left to do was to move forward with his life and to continue worshipping God. Essentially, King David stayed strong in his faith and continued moving in the direction God directed. It wasn't long before his wife was pregnant again and this time delivered a healthy baby boy. God is merciful to the faithful.

FAITH FOR A NEW DAY

Another story I'm reminded of is the story of Job. Job was a blameless man of complete integrity. Scriptures tell us that Job feared God and stayed away from evil. He had seven sons and three daughters. He

owned 7,000 sheep, 3,000 camels, 500 teams of oxen, and 500 female donkeys. He also had many servants. During this particular time period, Job was considered to be the richest man in his land.

God loved Job and he was highly favored and protected by God. Satan knew this and he became very angry. Satan approached God and told Him that Job only honored, feared, and served Him because God had a wall of protection around Job and his home and his property. He also told God that He made Job prosper in everything he does and because of that Job was a very rich man. Satan tried testing God and told Him if He was to take everything away from Job, Job would surely curse Him to His face.

God knew that Job's heart and love was very much genuine and sincere toward Him. He also knew that Job feared Him and had a deep desire to honor and please Him only. God gave Satan permission to test Job by taking everything away from him. He told Satan to do whatever he wanted to do, but not to take Job's life. The story goes on to say that Satan delivered a series of catastrophic events on Job's life and that his children and livestock were killed—his oxen, donkeys, sheep, shepherds, camels, servants,

his sons and his daughters. Even with everything taken away from Job, he did not sin by blaming God.

Even with everything taken away from Job, he did not sin by blaming God.

Satan approached God again, and this time he told God that Job continued to serve Him because he had good health. Once again God gave Satan permission to attack Job. God told Satan to do what he wanted to do to Job, but to spare his life. Satan proceeded with more attacks on Job, and this time he struck Job with a terrible sickness that caused boils to appear from his head to his toes.

While Job was struggling with the severe pain of soothing and medicating his boils, Job's wife approached him with great disappointment and commanded that he curse God and die. Job was not moved by his wife's strong commands or even by the pressures of being physically ill. Even with everything happening and falling apart all around Job, he refused to blame or curse God.

Eventually and out of frustration, Job begins to challenge God and question Him

about his life, the attacks and sickness that he was encountering. God strikes back and challenges Job with a series of questions that Job's wisdom could not comprehend or answer. At the end of God's series of questions, Job realizes that God's wisdom was way beyond his understanding. He also knew that he was questioning God out of ignorance and things that he knew absolutely nothing about. Job soon repented for his sins and humbly asked God for forgiveness.

God ended Job's season of testing and restored Job's fortunes and gave him twice as much as he had before. God blessed Job in the second part of his life even more than He did in the first part. Job now had 14,000 sheep, 6,000 camels, 1,000 teams of oxen, and 1,000 female donkeys. God blessed Job with seven more sons and three more daughters. The Scripture tells us that Job lived 140 years after that and lived to see four generations of his children and grandchildren. Job died an old man who had lived a long and full life.

> Even with everything stripped away from Job, he loved God and dug in his heels to serve and love Him wholeheartedly.

Even with everything stripped away from Job, he loved God and dug in his heels, he determined to serve and love Him whole-heartedly. Job knew instinctively that God was the Creator of all things and that He had the power and ability to give and the power and ability to take away. Although everything was taken away from Job, including his health, he stayed faithful and trusted and believed that God would eventually replace everything that was taken from his life.

In the end, God gave Job double for his trouble and beauty for his ashes. What if Job would have given up on God and life and died with his loved ones and his fortunes. Job would not have made it to his new day and his whole new world of blessings and opportunities. (See the book of Job in the Bible.)

THE FAITH THAT IGNITES GOD

God is so faithful to His Word. There will be times when everything around you is falling apart. It is during those times when you must trust in God and believe within yourself that things will get better and that

you will see a new day and be fully restored. Placing your hope, trust, and belief in God will ignite Him to bless you and shower you with His favor and blessings. By trusting in God, you are showing Him that you believe in Him and that you are expecting Him to do miracles and the impossible in your life.

One of my most favorite stories in the Bible is the story of Joseph. Joseph was a brother of twelve boys. Joseph was the son of Jacob who went through a very tough time in his life. Because of a dream (given to Joseph by God) that Joseph revealed to his brothers and father about him one day ruling over them, Joseph created an atmosphere of tension and jealousy between his siblings.

One day while his brothers were out pasturing their father's flocks, Joseph was sent by his father Jacob to check on the brothers and to bring back a report on their progress. As Joseph approached his brothers, out of their hatred and jealousy for Joseph, the brothers made plans to kill him. When Joseph approached his brothers with a series of questions about their progress, the brothers became enraged, ripped off the beautiful robe that Joseph was wearing, and threw him in an empty cistern. The very next morning the brothers sold Joseph to

a group of Ishmaelite traders as they were traveling to Egypt.

Joseph worked diligently and with the highest level of integrity and respect.

Joseph was then purchased by an Egyptian officer named Potiphar. When Joseph worked in Potiphar's field, Potiphar was so pleased with his work that he made Joseph his personal attendant and put him in charge of his entire household and everything he owned. Joseph worked diligently for Potiphar and served under him with the highest level of integrity and respect.

While working in Potiphar's house, Joseph was noticed by Potiphar's wife who was attracted to Joseph. She approached Joseph with sexual advances, but Joseph respectfully denied her. Out of rage, she accused him of rape and commanded her husband, Potiphar, to kill him. Potiphar was furious about his wife's accusations; but instead of killing Joseph, he sent him to jail.

While in jail, Joseph was given additional responsibilities by the warden who trusted him. God was with Joseph while he was in jail and ensured that Joseph succeeded in

everything that he was responsible for handling, completing, and overseeing. While serving in jail, Joseph was summoned to see Pharaoh, the ruler of Egypt. Pharaoh experienced some troubling dreams and asked Joseph to interpret them. With God's discernment, Joseph correctly interpreted Pharaoh's dreams, which brought Pharaoh great pleasure. Pharaoh immediately put Joseph in charge of his court and all of his people. Essentially, Pharaoh placed Joseph in charge of the entire land of Egypt.

Joseph was 17 years of age when he was sold into slavery and 30 years of age when he began serving in the court of Pharaoh. In spite of tragic episode after episode in Joseph's life, Joseph stayed faithful because he knew that God was with him during each storm of difficulty.

Joseph served successfully and was blessed beyond measure and received beauty for his ashes.

Joseph was given a wife and a new life. He served Pharaoh successfully for several years and was blessed beyond measure and received beauty for his ashes. Joseph was

now in the midst of a prosperous new life and successfully leading the land of Egypt.

Meanwhile, Joseph's brothers and family back in Canaan were experiencing a severe famine in their land. The brothers who sold him into slavery traveled from Canaan to Egypt seeking food. Because Joseph was governor of all of Egypt and in charge of selling grain to people in need, the brothers needed to speak to him.

When approached by the brothers, Joseph recognized them immediately but they didn't recognize him. Joseph knew that he was blessed and in a position to help them, but reflected on what they had done to him. When the time was right, Joseph pulled his brothers aside, confronted them with their actions, and revealed his identity. Joseph knew that God strategically ordered his steps to Egypt, made him an advisor to Pharaoh—the manager of his entire palace and the governor of all Egypt.

Joseph didn't die in his ashes or in his days of adversity, he pressed forward and repositioned himself to receive beauty for his ashes.

Joseph had much forgiveness in his heart toward his brothers. He was now in a position to save his father and his entire family from the deadly famine in the land of Canaan. With Pharaoh's consent, Joseph sent for his father and his entire family to come to Egypt and receive the very best the land had to offer.

Joseph's life was now fully complete. Not only did he receive a new life, he forgave his brothers and was now in a position to reach out, bless, and take care of them. By forgiving his brothers, Joseph was demonstrating God's love and showing that he was no longer holding on to the past. Joseph's trust in God and his forgiveness toward his brothers opened up many doors of opportunities for him to be blessed. (See Genesis chapters 37, 39, 41.)

Joseph didn't die in his ashes or in his day of adversity. Instead he pressed forward and repositioned himself to see and receive beauty for his ashes.

DOUBLE FOR YOUR TROUBLE

If you stay faithful and continue to honor God, God will give you beauty for your ashes. The Scriptures tell us to fill our horns with new oil; meaning to put on a new attitude. God promises us if we continue to honor Him and move forward, He will turn our darkest hour into our brightest hour.

> Don't die in your situation—allow God to restore everything that was torn away from you.

If something is dead or destroyed in your life, don't lay down in your ashes. Meaning, don't die with it. God wants to give us beauty for our ashes and double for our trouble. Don't die in your situation. Allow God to restore everything that was torn away from you.

THE UNCERTAIN ME...

As much as I continued to pray and read God's Word, I was still battling uncertainty in my walk. My feelings about my daughter's death seemed to test my faith and keep me from moving forward with my life. I prayed often and asked God to restore me and get me through my uncertain times. Reflecting

on biblical stories pertaining to losses and restoration, I prayed to God to touch my life and give me beauty for my ashes.

During my journey with God, there were times when my circumstances looked bleak. As a mother raising two children on my own, I needed to believe that God's blessings were on the way.

Over time, my circumstances continued to get better and better. Promotions at work were increasing, and my children were being blessed beyond my expectations. Eventually I met and married the man of my dreams. He was able to provide direction in areas where I needed a man's input and leadership in raising two young boys. His love and his understanding was a blessing from God. I truly see him as the beauty for my ashes.

I've learned that it pleases God when you walk in faith. As you increase your faith, your life will continue to prosper. Not only will God erase your pain, grief, and your struggles, He will provide you with abundance and beauty for your ashes.

Trying to restore myself after my great loss was the most challenging situation I ever faced. Accepting Jesus Christ as my Lord and Savior was the beginning of my path to restoration.

CHAPTER 11

Path to Restoration

Restoration is part of God's plans. Losing my daughter caused a tremendous vacancy in my life. Because of this great loss, I needed restoration in my mind and throughout my life. The feeling of regaining my thoughts and having confidence to move forward was desperately needed. To get back on track I needed a path to restoration. Fortunately, everything I needed was in the teachings of God's Word and having faith in those Words.

Trying to restore myself after my great loss was the most challenging situation I ever faced. Accepting Jesus Christ as my Lord and Savior was the beginning of my path to restoration.

> *"Restore our fortunes, Lord, as streams renew the desert. Those who plant in tears will harvest with shouts of joy. They weep as they go to plant their seed, but they sing as they return with the harvest,"* (Psalm 126:4-6).

God has provided us with many tools for restoration. Restoration tools can be found in many forms: reading God's Word, receiving the teaching of God's Word through pastors, inspirational music, and your church's Bible studies. Utilizing these tools can help you move forward during challenging times in your life. To cope with the loss of my daughter, I used many of these tools and made them part of my life in times of weakness.

Contrary to what God wants to use to restore us, some people go after temporary fixes. Many, when faced with emptiness, try to find restoration in the comfort of another person. No man or woman on the

face of this earth can restore your inner soul the way God can. Some turn to drugs and alcohol to numb the feelings of loss. These temporary fixes leave you more desperate and more wounded than you were initially. I knew that temporary fixes for me were dangerous and could possibly keep me from seeing my daughter again.

> Temporary fixes leave you desperate and more wounded than you were initially.

God is only interested in taking us to our new beginning and He understands what our needs are. God takes comfort in knowing that we are totally relying and depending on Him for our complete healing and restoration. It pleases God to see us restoring ourselves with His Word and other tools that He has provided for us. Staying on God's path brings Him excitement as we move forward to our new place in life.

After Trezoree's death, everything I did involved God. I began studying God's Word, listening to Christian music, and watching many spiritual television programs that spoke directly to my pain. Before long, my spirit became strong and my soul was

strengthened. I sought after God as if my life depended on it. I knew with everything inside me, if I stopped believing and allowing God to restore me, my life could possibly fall apart.

> ## "I'm doing fine because Trezoree is in Heaven."

As my restoration continued to take place, my spirit within began to overflow with joy. This happy spirit allowed me to move out of depression and any feelings of hopelessness about my loss. So often after a loss, many people feel obligated to sit around and mourn in their sadness. Where I was in my restoration process, my spirit spoke the exact opposite to me.

Many times after my daughter's death people gave me looks of pity, not knowing that my restoration process was well underway. They felt sorry for me and treated me as if I would never recover from the loss of my child. Whenever asked how I was doing, I responded, "I'm doing fine because Trezoree is in Heaven."

People did not know that I had a clear and real revelation of where my daughter

went after leaving this world. I was totally restored in that area of my life. After my response, they often smiled and nodded their heads in agreement. Many times I laughed inside, feeling that they possibly thought I lost my mind. I never accepted pity from people, which could ruin what God had restored in me about daughter.

My Husband from God

Twelve years after my divorce I fell in love and married a man who loves God. When I prayed for a husband to be part of my life along with my children, I needed specifics. I prayed for a leader, a strong father figure for my children, and committed husband who valued my relationship with God. My husband exceeds all my prayed-for expectations.

My husband possesses many qualities and characteristics that God knew I needed in my life and my children's lives. Neglect, verbal and mental abuse that I suffered in my first marriage was replaced with uplifting love, patience, and genuine support in every area of my life. My family now has a strong father figure who is committed to loving and guiding us through our everyday lives.

My husband not only loves God uncon-
ditionally, he loves me in the same and
devoted way. I thank God for the blessing of
life with an awesome husband.

> **Learn to rest in God's peace and wait
> on Him to divinely and strategically
> shape and mold your life.**

There's no way that I could have found
my husband on my own without God's divine
intervention. I prayed and waited on God to
provide me with the right spouse—the one
He knew would love and cherish me the way
He saw fit. God is faithful to His Word and
His promises. We need to learn how to rest
in God's peace and wait on Him to divinely
and strategically shape and mold our lives.

FINANCIAL BLESSINGS

Restoration in my life continued to
amaze me. For example, as my journey with
God deepened, I was blessed with financial
increases. Believing in and practicing the
biblical principles of tithing and offering
resulted in financial prosperity. Doors began
to open for me and my family with godly

increase. This was a chapter in my life when God provided for my needs and wants along with my children. Receiving financial blessings from God gave me more understanding of His power in financial situations.

When Trezoree became sick, I wasn't earning much during that year. My finances were tight and I struggled from paycheck to paycheck. After her death, I knew I needed restoration in many areas of my life, including financial resources. Having two other children with many needs, I realized that my financial situation had to improve.

Reading my Bible provided me with the tools I needed to experience financial increase. As I read my Bible, God began to show me the principles of increase. It's truly amazing how the Bible has an answer for every part of our lives.

With God's help, I was able to prosper in the workplace. I witnessed how opportunities and promotions were direct reflections of God's favor on my life. Following and obeying His principles led me to success— my career was flourishing.

Growing in my relationship with God and understanding His principles of tithing were the keys to all of my increases. Reading His

Word, I began to find Scriptures relating to the meaning of tithing.

In Malachi 3:8-12, God's Word tells us:

"Should people cheat God? Yet you have cheated me! But you ask, 'What do you mean? When did we ever cheat you?' You have cheated me of the tithes and offerings due to me. You are under a curse, for your whole nation has been cheating me. Bring all the tithes into the storehouse so there will be enough food in my Temple. If you do," says the Lord of Heaven's Armies, "I will open the windows of heaven for you. I will pour out a blessing so great you won't have enough room to take it in! Put me to the test! Your crops will be abundant, for I will guard them from insects and disease. Your grapes will not fall from the vine before they are ripe," says the Lord of Heaven's Armies. "Then all nations will call you blessed, for your land will be such a delight," says the Lord of Heaven's Armies.

I truly thank God for the favor of increase in my finances. As I continued to follow His teachings, I continued to receive His blessings in my finances. Having faith in tithing, I was able to remove myself from fears of lack into a daily expectation of increase. With

God orchestrating my career, I was placed in areas of leadership where I was able to help others excel in their abilities.

DON'T GIVE UP

Learning not to give up when there are setbacks during your restoration period is very important to the progress in your journey into understanding God's principles. Setbacks can show up in many forms: your acquaintances, lifestyle, finances, and even family members can play parts in challenging times toward your restoration. The key to not giving up is to stay in God's Word. His Word will open your eyes when your enemies are trying to close them. God's Word has an answer for every one of your setback questions.

There were times in my daughter's struggle to live when I was totally fatigued from the many doctor's visits, seeing her health deteriorate, and the fears of losing her. Never giving up on a miracle for my daughter, I was being restored through my daily Bible readings. At this time, although unaware of it, God was preparing me for whatever was about to happen. Through these extremely

tough times, I pressed on with my faith and later realized that God was giving me the strength to get through the even more challenging times yet to come.

Understand that during trying times, there *will be* a new beginning and restoration—do not throw in the towel. Don't let a bad situation or setback determine your future. If you allow your tragedy or your losses to define you, you could miss out on the blessings that God has prepared for you to receive.

As God continued to prepare me and restore me, I had moments of fear and doubt. Recognizing that the enemy truly wanted to break me and have me give up, I had to persevere by standing firmly on God's Word and His promises. Knowing and understanding the power of God pulled me through my most challenging times.

Concentrate only on the promise and not the process.

Please understand that many trials throughout your life come with a process of recovery. Believing in the wonderful promises of God that are attached to the end of

the process will put your faith in motion. Concentrate only on the promise and not the process.

There will be tough times when restoring yourself to the person God created you to be; don't allow the process to defeat you or steer you off course. Remembering God's promises will be your encouragement as well as your motivating tools. Continue to move forward with a no-quit attitude as you move into your new day and win each battle.

> My life and future became better and brighter with every step I took— yours will too!

Recognizing that God is the truth behind my inner strength along with my determination to keep moving forward was the power sustaining me and leading me to succeed in life. Walking and believing in the path that God placed me on were steps of faith. My life and future became better and brighter with every step I took toward restoring my life.

REFLECTING...

Reading God's Word and operating in His principles provide you with the tools to

move forward in restoring your soul. Understanding how prayer works is essential to your growth and development during challenging times and setbacks during your restoration period. The following steps are essential to becoming the person God destined you to be—and to being fully restored as a blessed child of your heavenly Father. These are the steps I took, and I have never regretted the journey.

PRAYER OF SALVATION

Your first step to restoration is confessing out loud that Jesus Christ is your Lord and Savior.

Romans 10:9-10 (AMP) says:

> "...because if you acknowledge and confess with your mouth that Jesus is Lord [recognizing His power, authority, and majesty as God], and believe in your heart that God raised Him from the dead, you will be saved. For with the heart a person believes [in Christ as Savior] resulting in his justification [that is, being made righteous—being freed of the guilt of sin and made acceptable to God]; and with the mouth he acknowledges and confesses [his

*faith openly], resulting in and confirming
[his] salvation.'*

RECEIVE THE HOLY SPIRIT

Every believer needs to be filled with the
Holy Spirit to experience the power and
assistance of the Helper.

Luke 11:10-13 (AMP) says:

> *"For everyone who keeps on asking
> [persistently], receives; and he who keeps
> on seeking [persistently], finds; and to him
> who keeps on knocking [persistently], the
> door will be opened. What father among
> you, if his son asks for a fish, will give him
> a snake instead of a fish? Or if he asks for
> an egg, will give him a scorpion? If you,
> then, being evil [that is, sinful by nature],
> know how to give good gifts to your chil-
> dren, how much more will your heavenly
> Father give the Holy Spirit to those who ask
> and continue to ask Him!"*

PRAYER OF REDEDICATION

If you love God but have been in a
backsliding position, you can rededicate

your life to Jesus Christ at any time—including right now.

First John 1:9 (AMP) says:

> *"If we [freely] admit that we have sinned and confess our sins, He is faithful and just [true to His own nature and promises], and will forgive our sins and cleanse us continually from all unrighteousness [our wrongdoing, everything not in conformity with His will and purpose]."*

FIND A CHURCH HOME

Finding and partnering with a church that has a Bible-believing pastor who is dedicated to God and His people is key to your growth and development.

Jeremiah 3:15 (AMP) says:

> *"Then [in the final time] I will give you [spiritual] shepherds after My own heart, who will feed you with knowledge and [true] understanding."*

God's restoration process for me included not only restoring my mind, it also included restoring everything around me.

I pray that you will take each of these steps that leads to immediate progress on your journey to living life according to God's unique and specific purpose and plan for you. You, like me, will be amazed at all the wonderful gifts He has waiting for you along the way.

Whatever you feel God has placed in your life to do, have faith and pursue it. Taking steps of faith activate God to move on your behalf and you'll begin to see new life springing forth on your journey.

CHAPTER 12

A New Day

Going through and dealing with a traumatic episode in your life takes an incredible amount of willpower, along with determination. It takes willpower to accept the loss of a child or loved one and determination to move forward and pursue a new beginning. Pursuing a new beginning allows you to move forward into God's plan for your new life. Moving forward will activate God's plan of purpose in your journey of new beginnings.

Losing someone is very difficult—but losing yourself in your loss is not what God wants for you. Feeling hopeless and over-powered by grief prevents you from moving forward and stepping out of your state of despair. There is no giving up on God's purpose to restore you; His plan will move you in the direction of glorious new beginnings.

Isaiah 43:18-19 (AMP) says:

"Do not remember the former things, or ponder the things of the past. Listen carefully, I am about to do a new thing, now it will spring forth; will you not be aware of it? I will even put a road in the wilderness, rivers in the desert."

YOU determine what you will overcome and what you will allow to take you under.

Deciding how to deal with the obstacles you face totally determines your progress toward your new day. *You* are the deciding official of what you will overcome and what you will allow to take you under. God never intended for any of us to remain in mourning or in a place of stagnation.

Early on during my grieving process, I received a clear revelation of where my

daughter was and what I needed to do in my life to make sure one day I would see her again. That revelation alone gave me the courage and determination to press my way through my trials and my challenges. I knew if I stayed on course with God's Word, I would soon restore my happiness and walk into my new day of renewal.

Not having a vision or dream from God shouldn't stop or hinder you from believing in His power or His ability to restore your life. God is certainly real and He wants every day of your life to be blessed and motivated to serve Him. Count your blessings, move forward, and expect the very best of everything to enter your life.

As you look back on your life and reflect on past events that were truly blessings, understanding where those blessings came from will bring clarity as you move forward. Know that God walked you through each challenging situation. Have faith in God's Word and believe that because He got you through something before, He can surely do it again.

In the years after I lost my daughter to leukemia and was raising two children on my own, I knew I had to give 100 percent of

myself to God to ensure I would continue to receive His promises. I held on to God's promises and believed that my life would grow in a positive direction. I knew God was restoring me; but He also was preparing me for my future. I understand now that I was my own worst enemy regarding setbacks. Learning from my mistakes, I was able to make mature decisions when I needed to get back on track.

Dwelling on your misfortunes will not allow you to reach your potential in receiving God's promises. Trusting in God's ability, along with His power, will shake off doubt and unbelief and catapult you into your days of blessings.

As you step into your day of new beginnings, it's crucial to be open to follow your dreams. We live in a world where there's a tremendous amount of opportunity waiting for you to grab. It's time to make your mark and pursue your dreams. Whatever you feel God has placed in your life to do, have faith and pursue it. Taking steps of faith activate God to move on your behalf and you'll begin to see new life springing forth on your journey.

As you enter into your new days, continue to think positively and chase after your dreams with passion. Be consistent and always put God first in your steps. Make a statement wherever you go that God has blessed you and is providing you with the tools to prosper.

Picking up the pieces that once crumbled around you and moving forward demonstrates how strong, courageous, and brave you are. Do not let past perceptions or people's opinions of you hold you in bondage. Continue to demonstrate God's love and show the world that your life is at peace, even though you experienced the loss of a loved one.

Understanding that your saved loved ones in Heaven have received victory in their deaths should inspire you to move forward with your victories here on earth. Remembering to thank God and praise the name of Jesus Christ in every victory shows Him— and those around you—how much you're honoring Him with gratitude and love.

Have faith and expect to receive the very best!

Continue to walk in faith and pursue your dreams. Having faith allows you to have the expectation of receiving God's best. Now that you are a child of God, you can rest and allow God to work in every area of your life.

God has truly provided me with a life of happiness and abundance. One of my most tremendous blessings from God is having a husband who walks in faith with me. God's love and power is unlimited, all I needed to do is tap into it with faith and expectation. Having defeated my feelings of hopelessness in many areas has allowed all of my wonderful dreams to be birthed into existence.

Having a clear revelation and trust that my daughter is with God has freed me to move forward in completing great accomplishments in life. I no longer feel any condemnation over the great loss of my daughter. I have allowed God to open up new doors in my life that gave me the ability to start beautiful new chapters. The joy of believing that God loves me so much brings peace and contentment to my heart. God loves me so much that He sacrificed His only begotten Son so that I can be reconciled with Him. Believing that my daughter is in Heaven and enjoying eternal peace in

God's love has allowed my new life and journey to begin.

God can do the very same for you—and your new life and journey can begin today!

Not an Ending~a New Beginning...

Everyone has a story to tell—how will yours be told? Will you be courageous, seek God, and ask Him for restoration? Will the time ever come for you to boldly tell yourself, "This is my life and I deserve to be happy"? What's holding you back from moving forward and receiving more out of life? Surely you deserve to receive God's very best in your life; after all, Jesus died to give you abundant life on earth and eternal life in Heaven.

While traveling down the road of life, you will be faced with challenges and trials. How you handle each challenge and trial determines how successful you will be at conquering and overcoming the ones ahead. A trial is just a bump in the road—something

to get over and move past in order to continue on your life's journey.

Be brave and rejoice; this is not an ending but a new beginning. Go through your life with boldness and tenacity. Don't give up or allow yourself to be overtaken by any circumstance or challenge.

Be courageous and take a chance on God—allow Him to establish your new beginning. If you allow God to heal you and work things out in your life, you will soon receive a transformation filled with purpose, happiness, and fulfillment of your God-given destiny.

I'm wishing you the best and cheering you on.

Remember, new beginnings may be disguised as painful endings!

Prayer of Salvation

If you are not saved or have not made Jesus Christ the Lord and Savior over your life, please speak the following words out loud and proclaim them in your heart:

Dear God in Heaven,

I come to You right now in the name of Jesus. Your Word says that whoever comes to You will in no way be cast out, but that You will take me in. I thank You for it. You also say if I confess with my mouth the Lord Jesus and believe in my heart that God has raised Jesus from the dead, I shall be saved. Therefore according to Your Word, I believe in my heart that Jesus Christ is the Son of God, and I believe that Jesus was raised from the dead for my justification, and I accept Him now as my Lord and Savior. I

have now become the righteousness of God, in Christ Jesus, and I thank You, Jesus, for saving me. In Jesus' name.

BELIEVE IT AND RECEIVE IT NOW IN JESUS' NAME. AMEN!

Welcome to the family of God.

It's time to live again and make your life count!

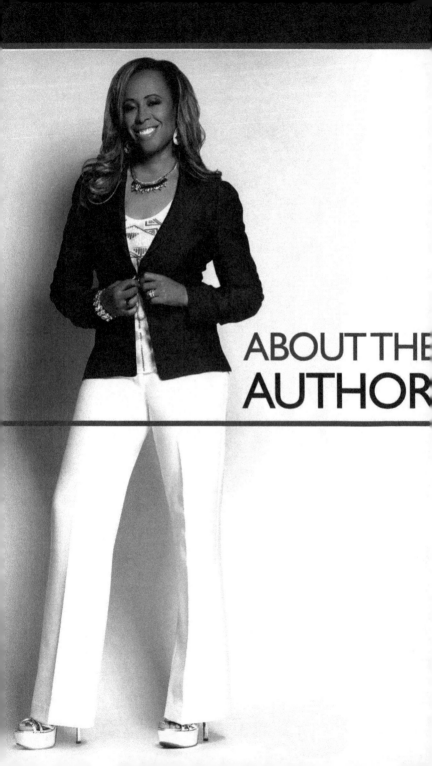

ABOUT THE
AUTHOR

Tracey Smith seeks out the hopeless, lost, and brokenhearted to share her story of overcoming great personal loss and stepping into a new day. She is an inspirational and motivational speaker whose audiences can easily grasp for themselves the hope and grace she found in God. Tracey is zealous and eager to reach out and counsel those who may have given up on life and can't yet see their new beginnings. She uses an honest, raw approach that immediately captures her audience's attention.

Tracey is known for connecting and building solid relationships with men, women, and children of all ages. Her sweet spirit and kind demeanor attract people toward her in a trusting manner, helping them overcome suffering and grief. Giving up and throwing away dreams is never an option; she is committed to establishing connections and overseeing the well-being of each hurting soul.

Tracey is a loving wife and devoted mother of two awesome sons. In her downtime she enjoys family trips, reminiscing about past blessings, and thanking God for giving her a new beginning filled with His unfailing love.

Tracey Smith
INSPIRATIONS

www.traceysmithinspirations.com

info@traceysmithinspirations.com

www.facebook.com/Tracey-Smith

www.instagram.com/traceysmithinspirations